IN RESPONSE TO PLACE

PHOTOGRAPHS FROM THE NATURE CONSERVANCY'S

LAST GREAT PLACES